Finding Myself

a collection of poems

noor afasa

BookLeaf
Publishing

India | USA | UK

Made with ❤ on the BookLeaf Publishing Platform
www.bookleafpub.in
www.bookleafpub.com

Dedication

To those who make life better,
I appreciate you.
I pray you are always happy and healthy
Ameen

Preface

This book includes 21 poems that have been written in 21 days, and so although these poems won't be the best, edited versions, I am grateful to be able to share them. Thank you for choosing to read my poetry - it means a lot!

In this book, I have wrote poems without actually putting too much thought to what I should write about but instead, what naturally comes to me, which has been very nice and reflective. I hope you enjoy your read!

Acknowledgements

Thank you to everyone who has come into my life, bringing even the slightest bit of happiness.

Family and friends, thank you for endlessly giving me your love and support. You are always in my duas.

I want to thank the Performance Collective for inspiring me but also, always making me feel like an inspiration.

And Safa, thank you so much. Thank you for being such a good friend and always being the first to read my poems.

Last but certainly not least, my Ammi. No matter how many times I say 'thank you', I could never thank you enough. I may not say it as much as I should, but I love and appreciate you more than words could ever express. Thank you for believing in me and supporting me.

1. accent

me and my dad don't speak the same language
and, neither do we share the same accent.
our r's roll of our tongues in different ways:
mine comes easily and natural,
his, shy and hesitant.
not because he struggles to say it
but, because he thinks twice
before saying it in front of you.
because his r's come from a rural village,
from karak chai,
from the roundness of rotis,
and an unwritten language,
whilst
your r is the one in ignorance
in front of which,
my fathers r rolls up, bends, bows and shrivels in shame.
in front of which,
his voice becomes
small.
because you only hear those

who speak like you do.
because you don't like how his words sound,
because when i stretched your moth
and pulled the alphabet out,
ignorance is the only thing i found.

2. the echo of bangles

when my bangles jingle,
they sound just like my grandma's.
and they shine just like hers do,
round and reflecting the sunlight, just like the moon.

but when my bangles jingle,
it's not just my grandma's they echo,
but all the women who came before.
women who passed on what they know.

although i am made of those women
and what they know,
and just because our bangles sound and shine in
the same way,
and have done so for so long,
i will not continue the things that we know,
that we know are wrong.

i will not let my bangles sound louder than my voice.

and when i pass mine on,
rather than as shackles on her arms,
i will place them in her palms.

3. my city

i come from a city
with such beautiful history.
the Brontës, Hockney and Priestley.
endless creativity
because we do things differently.

i come from the wool capital of the world,
with some of the most famous mills,
a gateway to the countryside
and the greenest hills.

Bradford.
originally known as 'Broad Ford'
but what are we really known for?
over 120 languages spoken
yet we speak as one.
us Bradfordians welcome you as our own.

i come from a city of film, magic and art -
with people so talented and bold.

our food, unforgettable
our cars, unbeatable
and our spark, unimaginable!

i come from a youthful spirit.
29%, remember that number,
excitement and change,
what's next? i wonder

a city that once thrived,
will thrive once more.
a city with drive,
never seen before.

i come from a city,
making such beautiful history.
i come from Bradford.

4. remembering you

you say to remember you,
so i do.
i carry your name on my tongue
and in my heart,
even carry you in my curved palms.
i call for you
when the silence is loud,
when the night is dark,
and the sun has found rest.

i call for you and the silence remains,
but i know you're listening.
i call for you and i'm alone,
but i know you're there.
and when i don't call for you,
i know you're waiting.

5. drowning

the sound of silence is loud.
it's the waves still and calm,
on shore
but the waves fighting each other
out at sea.
and if i was the ocean, this is how i'd be,
silent and smiling
just how you want me,
but
in the places where you can't reach me,
i would still be screaming
underwater
in hope you'll hear me.

if i was the ocean,
my waves would carry guilt,
because i stay silent when i shouldn't.
i'm scared of the shame that comes with speaking up.
and why speak when you don't listen?

and if i was the ocean,
the waves would whisper to me instead;
'we have been here longer,
we know better.'

because i'm a girl and i'm young
and i know nothing.
but maybe if i was the ocean,
i wouldn't have to scream but
you would come to me.
silently or smiling, it wouldn't matter
because you would sit by me
and

maybe if i was the ocean
you would
willingly listen to me.

6. woman

to be a woman
is to be many a thing.
it's to give
when you can no longer give.
it's your body losing dance
so instead you sing.

7. children of jannah

i don't know how to write this poem,
because i don't know what to say.
usually hope God understands me as i put my hands up
and pray.
but today, as my hands write
i don't want to say i wish this wasn't happening
because God is the best of planners
and at the end of the day,
these are the children of jannah.

these children suffering an unimaginable pain.
even in their screams,
they take God's name.
and it amazes me
because they don't call it in vain.
they whisper it under rubble, to the dust and to the rain.
the same dust that will rise and testify on the day
of these children's unwavering faith.
they speak it with such admirable confidence and
strength.

these children with love for their God
and strength bigger than their little bodies.
like they know He is listening,
because they know there's better rewards for their
suffering.

and i promise to not complain,
because the difference between me and them
is pure luck.

because as i stand and wash the dishe,
i look out of the window and try to imagine.
how i would feel
what it would look like
maybe how i'd scream
if i saw bombs dropping from the sky
but forget feelings, i can't even imagine what that would
look like.
and it breaks my heart that this is daily, an every day
all they know
for the children in Palestine.
the children of paradise.

8. lock me in a jar

lock me in a jar
and leave me on your shelf.
so you can pick it up
and show me to your friends.
breathe on the glass
and scrub with your sleeve,
making sure you can clearly see.
and if i try to hide
pull the lid tight
so i can't breathe
and will give in, letting you see.
or poke your finger in
and force up my chin,
or pluck a hair
and threaten me "if you dare".
snatch all the other women you see
and place them in jars next to me.
because it wasn't just me you stared at alone,
but you stared at us all.
and although no one may hear us from the jars,

let the line of jars tell herstory.

9. piece of poetry, piece of me

sometimes i wish,
i could crawl out of my skin
flow into my pen
and become the very ink,
that fills page after page
of things i struggle, i'm unable,
i can't bring myself to say.

i wish you'd realise
that words have writers
and these words are written
written by,
me.
i'm not writing a story
something for you to nod and clap at.
neither is it about me performing for you whilst you sit
back
but a piece of poetry
is a piece of me

and when i say read this,
i'm letting you see me.
giving you permission to pick at the seams,
pull out the stitches
and see what lays beneath,
rip back the layers of fabric
so you can see
the very cloth i'm made of
so you understand
that my poetry
is a part of
me.

10. i come from

i come from being ashamed of my tea bag-stained skin,
to being proud of my brown beauty.

i come from a family,
a family who drink chaa four times a day,
who come from a country so beautiful,
yet so corrupt.
a land of spices, samosas and sun.

i come from strong women with strong, mehndi-stained
hands.
intricate designs painted across their palms.
i come from the singing of traditional folk songs,
songs we've heard our mothers,
who've heard their mothers, sing.
i come from a place where us women greet each other -
with a handshake and two pecks,
where the men place a respectful hand on the young
girl's head.

i come from shame, respect and love.
i come from my family, who come from Pakistan.
i come from a culture I love.

11. finding home

when i feel a little lost
and the noise is louder,
when the ground is shaking
and the world feels busier,
the only way to steady myself
is to cross my hands over my chest,
so instead of the noise
i listen to my heart,
and i stand still
in hope that the world will do the same.
and to stop the shaking,
i lay my forehead on thr ground,
eyes closed, and call for my Lord.
whispers so close to the ground
yet, reaching the highest of heavens.
when i feel a little lost,
i try to find
my way back home.

12. death

you lay, peacefully
with a smile on your face
seemingly happy and at ease,
despite the crying and grief
surrounding you.
are you not aware of this pain
or does death turn people selfish?
so many questions i could ask you.
your eyes easily closed
as if you're sleeping,
is that how it feels?
as if any moment now,
your eyes will open.

guilt befriends grief,
because i've already forgotten
what your eyes look like.
whether they shone when you laughed.
i don't think i've ever seen yu c ry,
what did tears look like in your eyes?

they say eyes are a window to the soul,
but where has yours gone?
how can i continue to know you
if your window has now become bolted and shut
boarded up.
i try my hardest to remember staring into them,
i wonder what they looked like
staring into those eyes,
the eyes of death.
did you try fighting back
or did you feel prepared?
did you simply accept
or were you scared?
it's a weird thing to accept i am never going to see you
live, laugh, cry or speak again.

13. brown bodies

our bodies don't look like yours.
a very embarrassing fact,
when i was a little girl.
embarrassed of her thicker hair
and of her darker skin.
i wonder why she believed that
being brown was a sin.

maybe she knew how you looked at her,
sneakily, as though you weren't allowed to.
the way you refused to touch
or befriend her.
or dismissed the correct way to say her name.

and now i've learnt why our bodies aren't the same.
why your backs stay stiff
and head only ever facing straight,
because you know no one is going to come in your way.

our bodies don't move like yours.

mine isn't stiff, it easily falls.
but then i learnt about how it carries a heavy load.
the same heaviness of my ancestors,
the heaviness of your success,
built upon their brown backs.
my brown body doesn't move like yours
because my body comes from those
whose backs bend backwards
upon your call.
who wouldn't bat an eyelash,
who would face the other way,
who would endure all the pain,
because their bodies are wrapped in a different skin.
yet, i believe God made us all of the same clay.

but yes, your body is not like ours.
we share the shine from the sunlight,
our skin outshining our gold.
embodiments of the sunrise itself,
our bodies carry the love of the sun
and stories, untold.

yes, our brown bodies are beautiful
even though they're not like yours at all.

14. what will others think?

sometimes i get excited,
wanting to try new things.
but then i have to look down at my hands,
remind myself of the colour of my skin.
and ask myself,
what will others think?
not that i really care
but *banday keh sochsan*?
suddenly the voice in my head
sasn't my own
but, my voice was whispering somewhere
asking,
who are you living for?

a line that has broken brown hearts too many times.
a line that has stopped so many from living their lives.
because '*banday ke aaksan*?'
what will others say?
a mindset that has stopped parents, grandparents and
generations before,

all asking each other about others,
but let's not stop ourselves anymore,
remind yourself who you're living for.
because
people will always think
and people will always speak
but, i don't want to die
without actually living my life,
because i asked myself wayyy too many times
what will others think?

15. growing up

somewhere between then and now,
a little girl became a woman.

she learnt of her mother's troubles;
she learnt what it means
and, how it feels,
to be a woman.
how hard it must be
to go from living for yourself to living for others.
she finally understood how her mum juggles,
the emotions of her own
but keeps it hidden, so that she is able to first help
others.
help the little girl, her sisters and brother.

and how annoying it must be
when us children think why she's screaming,
over such a little thing
not knowing that there's bigger things
for her to think,

and that, that little scream is nothing
compared to what she's seen
and, how she really feels.

a little girl,
who didn't know any better,
grew up to see
the bittersweet
reality of being a woman.
constantly giving yourself to an ungrateful world
that will only ever,
ask for more.

my mother.
a woman who constantly endures and endures,
to make the world a little better
for her four children.
a woman whose mere silence
is a bigger sacrifice.
what the little girl originally thought was weakness
soon realised,
everything her mum did was
for her children,
to be happier in life.
so for all the women
who have given themselves
to this ungrateful world,

and lost their sense
of who they are,
i want to thank you
for the women you are.

this is a poem for you.

16. untold history

two sides
they say there's two sides to a coin.
and it's the same with history,
every story.
but a side is a side,
and a lie is a lie.
so don't dry up my grandparents tears
with the fabricated lies
you've told for years.
that you've printed on pages
that have taught me about history.
things like britain's industrial revolution.
because my grandad's hands
and quiet mouth
tell a different story.
the cloth that was spun and woven by him
in a Bradford mill,
the fabric that has been made
by his very hands,
gets labelled 'british made',

no trace
of the pakistani hands that gave and gave,
to this country that won't accept his people to this day.
you failed to recognise him as british
and for me who was born here,
you gave me a checklist.
as if to calculate
what percentage of me is truly british.
but let me ask you the same
because britain isn't just britain,
if it's built upon the backs of others.
made up of what you have taken and taken.
if it's built upon the people you called,
who came and gave their all
just to do play their part
in a bigger puppet show,
just to get told
to "go back home"
"where you came from"

but how could you appreciate?
how could you be thankful for my grandad and others
like him?
if instead of seeing
his hard-working, wool-spinning, loving and feeding
hands,
you saw the colour of them first.

so before you paint yourselves as
the heroes in history,
i remind myself that
they say there's two sides to a coin.
but, unfortunately i soon realised
this coin was made by you.

17. ugly

the mirror isn't my friend.
i walk past her,
stop to smile and play pretend.
without actually speaking,
she makes me feel ashamed.
and without actually moving,
she zooms in.
to show me all my flaws
and i must admit,
it pisses me off.
because i have other friends
who speak and don't make me feel ashamed.
who make me feel pretty
and will do so, again and again.
yet,
i can't help myself.
even when it's dark and there is nobody there,
i go back to the mirror
and stare.
even though the mirror isn't my friend,

i believe her
over the rest.

18. finding love

they told me you found love.
and i looked everywhere,
to find the one whose name you call,
last thing in the night
and first thing at first light.

but i couldn't find anything at all.
i looked up into the sky,
even looked between the stars.
And even looked to the dust
yet, i had no luck.

who is the one
that you have given all your love?
and when i asked you this
you answered, 'i carry His name on my tongue'
so i asked you where i could find him
and, instead of giving directions,
you gave me instructions
told me to cross my hands over my chest

and, steady myself.
put my mind to rest by
putting my forehead to the floor,
told me to call Him
and that was all.
the one you love,
i found within the fabrics of my being
and very soul.

19. my favourite colour

i like the colour brown.
it's my favourite colour.
i like the way
brown clothes suit my skin.
i like the way
brown is my skin,
how it outshines our gold.
i like my tea the same colour,
the same colour
as my tea bag-stained skin.
i like brown,
because it reminds me
of the richness of soil,
the richness within
my mother's eyes,
a cup of tea,
and autumn leaves.
if this colour was a person,
they would have the warmest hugs,

and bring you comfort.
brown is my favourite colour.

20. islamophobia

oh i am so sorry.
i do apologise, that you feel uncomfortable.
nothing to do with my behaviour
but, in your eyes
all muslims are the same.
and the muslim you saw on the news,
i must be the same, right?

yet, i do not see your white skin
and ask you,
why you colonised
because my eyes
see you before seeing your skin;
don't look at the exterior
because what matters is what's within.
and within you,
only exists ignorance.

because every time i smile,
at a white person,

i convince myself it's out of niceness
yet, i cant help
feel like i'm proving myself.
showing you i'm not a threat.
but, i can't help
when i notice you look me up and down
like, iv'e given you a reason to be scared of me.

all i did was smile
but yes, i am so sorry,
for your own ignorance
that makes you so scared of me.

21. grandma's garden

my grandma's garden.
my grandma's plants are fed, watered and loved.
she cares for them,
the same love she gave us.
the same hands
that pick and plant,
that picked and raised us,
hold so much love.

my grandma's garden is a reflection of her love,
how it shines, blooms and colours.
and us grandchildren
come from her garden of love.

www.ingramcontent.com/pod-product-compliance
Ingram Content Group UK Ltd.
Pitfield, Milton Keynes, MK11 3LW, UK
UKHW021428050125
3962UKWH00041B/690

WISEBLOOD ESSAYS IN CONTEMPORARY CULTURE No. 4

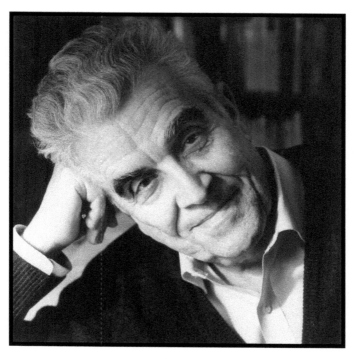

RENÉ GIRARD

"EVERYTHING CAME TO ME AT ONCE"

THE INTELLECTUAL VISION OF RENÉ GIRARD

CYNTHIA L. HAVEN

WISEBLOOD BOOKS

2024

WISEBLOOD BOOKS
P.O. Box 870 Menomonee Falls, WI 53052
www.wisebloodbooks.com

I

Midway in the journey of our life
I found myself in a dark wood,
for the straight way was lost.

DANTE ALIGHIERI
Inferno, *Canto I*
trans. Charles Singleton

René Girard had reached the traditional midway point of life—35 years old—when he had a major course correction in his journey, rather like Dante. The event occurred as the young professor was finishing *Deceit, Desire, and the Novel*[1] at Johns Hopkins University, the book that would establish his reputation as an innovative literary theorist. His first book was hardly the only attempt to study the nature of desire, but Girard was the first to insist that the desires we think of as autonomous and original, or that we think arise from a need in the world around us, are borrowed from others; they are, in fact, "mimetic."

Dante's "dark wood" is a state of spiritual confusion associated with the wild, dangerous forests. Three beasts block his path; the leopard, the lion, and the wolf represent disordered passions and desires. Dante's conversion begins when he recognizes that he cannot pass the beasts unharmed. Girard experienced his "dark wood" amidst his own study of the disordered desires that populate the modern novel. His conversion began as he traveled along the clattering old railway cars of the Pennsylvania Railroad, en route from Baltimore to Bryn Mawr for the class he taught every week. While reading and writing as he chugged along between the cities, he underwent what in today's clinical and somewhat prissy modern jargon are called "altered states"—and they apparently continued with more or less intensity for several months.

5

Girard's conversion is no secret, but what's less commonly understood is that it was born in an experience that he has spent his entire life trying to explain. "Conversion is a form of intelligence, of understanding,"[2] he said. "Conversion experiences" don't always lead to a change in religion; and not all conversions are rooted in an altered state—but for Girard, the two went hand in hand. The watershed marks Girard's transition from being a clever, up-and-coming lit critic to something far more profound.

It happened this way: "In autumn 1958, I was working on my book about the novel, on the twelfth and last chapter that's entitled 'Conclusion.' I was thinking about the analogies between religious experience and the experience of a novelist who discovers that he's been consistently lying, lying for the benefit of his Ego, which in fact is made up of nothing but a thousand lies that have accumulated over a long period, sometimes built up over an entire lifetime."

He found that he was undergoing the same experience that he had been describing in *Deceit, Desire, and the Novel.* "The religious symbolism was present in the novelists in embryonic form, but in my case it started to work all by itself and caught fire spontaneously," he said. He never explained what, exactly, he meant in this cryptic sentence; events that happen outside time and space are very difficult to describe within it. However, he could no longer have any illusions about what was happening to him, and he was thrown for a loop: "I was proud of being a skeptic. It was very hard for me to imagine myself going to church, praying, and so on. I was all puffed up, full of what the old catechisms used to call 'human respect.'"[3]

"I have never spoken about my conversion, because it seemed to me difficult, embarrassing, and a topic too dangerous to be approached," he said in 1990.[4] He later qualified, "The word 'dangerous' is excessive. What I meant is that my Christian faith is impeding the diffusion of the mimetic theory, given that academics

6

today feel the obligation to be anti-religious and keep religion at bay."[5]

One senses considerable caution in his explanation. Maybe he'd given up trying to decipher what was so easily misunderstood by almost everyone, including the Irish priest in Baltimore to whom he turned for his first confession since childhood. His experience changed everything, but perhaps the first thing it changed was *Deceit, Desire, and the Novel.*

Sandor Goodhart, the friend and colleague who had daily conversations with Girard a decade later, described to me the impact on *Deceit, Desire, and the Novel,* and how it changed the way Girard viewed the writers he discussed in that work. Goodhart recalled his own education, and the rationalizations that were offered to dismiss deathbed conversions in literature: "It was always presented as 'Writers say this, but they're saying it because they're afraid they're dying, blah, blah, blah—so we can't really take it seriously.'" Girard told Goodhart that he had felt the same way. "But then suddenly, his own personal experience suggested to him that something serious was taking place in these works." Girard began to reconsider the conclusion of the novels he was writing about, and, in doing so, he made a more serious attempt to reach these authors on their own terms. His own life had given him the evidence to do so.

He rewrote the conclusion, and apparently rewrote other passages in the otherwise completed work, weaving his new understandings into the whole. The authors, he saw clearly, were describing how they were being freed from their own secondhand desires. With that new understanding, they *became* their stories in a new way, with a wisdom previously inaccessible to them. The emergence from the prison of imitated desires mediated by our rivals was the basis for the major novels—by Flaubert, by Stendhal, by Cervantes, by Dostoevsky, by Proust—he was reading. The emergence from prison to freedom, and a little more besides.

Even the shelves of books he eventually wrote couldn't tell the whole story. It was just the beginning. The novels he described in *Deceit, Desire, and the Novel* were two-dimensional, flat on a page, but the only possible response he could have was to live out the same narrative in his four-dimensional life through time—just as the authors he had been writing about had done, after finishing the last pages of their own novels. *That* was the ending after the ending.

II

His first book would prove to be only the beginning of his fascination with what he calls "metaphysical desire"—that is, the desires we have when creature needs for food, water, sleep, and shelter are met.

Human behavior is driven by imitation. We are, after all, social creatures. Imitation is the way we learn: it's how we begin to speak, and why we don't eat with our hands. It's why advertising works, why a whole generation may decide at once to pierce their tongues or tear their jeans, why pop songs rise to the top of the charts and the stock markets rise and fall.

The idea of mimesis is hardly foreign to the social sciences today, but no one had made it a linchpin in a theory of human behavior, as Girard did, beginning in the 1950s. Freud and Marx were in error: one supposed sex to be the building block of human behavior, the other saw economics as fundamental. But the true key was "mimetic desire" which precedes and drives both. Imitation steers our sexual longings and Wall Street. When a Coca Cola advertisement beckons you to join the glamorous people at a beach by drinking its beverage, mimetic desire poses no immediate privations—there is enough Coca Cola for all. Problems arise where

scarcity imposes limits, or when envy eyes an object that cannot be shared, or one that the possessor has no wish to share—a spouse, a private bank account, the top-floor corner office.

Hence, Girard claimed that mimetic desire is not only the way we love, it's the reason we fight. Two hands that reach towards the same object will ultimately clench into fists. Think of Shakespeare's *A Midsummer's Night's Dream*, where couples dissolve and reassemble, tearing friendships asunder as the two bewitched men suddenly want the same woman.

Eventually, the community sees one individual or group as responsible for the social contagion—generally, someone who is an outsider, who cannot or will not retaliate, and so is positioned to end the escalating cycles of tit-for-tat. The chosen culprit is therefore a foreigner, a cripple, a woman, or, in some cases, a king so far above the crowd that he stands alone. The victim is killed, exiled, pilloried, or otherwise eliminated. This act unites the warring factions and releases enormous social tension, restoring harmony among individuals and within the community. First the scapegoat is a criminal, then a god. More importantly, the scapegoat is both, since the single-handed power to either bring peace and harmony or war and violence to a society is seen as supernatural. Oedipus is deified at Colonus, Helen of Troy ascends Mount Olympus, and even as Joan of Arc is burned at the stake, the mob begins to murmur, "We have killed a saint!" Archaic religious sacrifice, Girard argued, is no more than the ritual reenactment of the scapegoat's killing, invoking the magical powers that previously preempted a societal catastrophe.

His next step was to prove the most provocative of all: he would go on to describe how the Judeo-Christian texts are unique in revealing the innocence of the scapegoat, thus destabilizing the violent solution to social violence, the mechanism that allowed the victim to be both criminal and redeemer. Hence, we no longer have clean consciences as we murder. Individuals and groups today

even compete for the cachet of being a victim in the Oppression Olympics, as the power-holders play defense. Wars continue, but end with no clear resolutions. International rivalries still escalate, but towards uncertain ends. The stakes are higher than ever today: we teeter on the nuclear brink.

III

Girard's theories about violence, sacrifice, and scapegoating would unfold in the coming years, but first he had to face an incredulous circle of friends and colleagues.

Prof. Richard Macksey, a legendary polymath at Johns Hopkins, confessed that he was so accustomed to the French being anti-clerical that he was taken by surprise. John Freccero, who had just received his PhD and would go on to become one of the century's leading Dante scholars, made the same assumption: "He was very interested in Sartre, Albert Camus. He was much, in a French way, a leftist, really—nothing Roman Catholic about him." Nevertheless, Freccero claimed he saw the roots of the invisible tree, including the influence of Girard's devout mother in Avignon, where his father was a notable regional historian and curator of the Calvet Museum and later the Palais des Papes, and the effect of the Provençal years generally. The seeds were sown, waiting for the watering can, waiting for what "seemed a historical moment" to Girard. "The rest of us could see it coming," Freccero told me.

This would have been news for Girard, who described himself as a reluctant convert. Freccero recalled a conversation with the Romance Languages department chair Nathan Edelman, a French Jew, "who was certainly very touchy about Christianity. He said something to Girard, very lightly, about moving to the right

politically and socially. Girard said, 'Nathan, you cannot believe it, but I have been kicked into a change of religion.' His experience with the spiritual was like a kick externally. Something he was forced into." It usually occurs like that, Freccero added. People imagine lightning bolts, "but it doesn't work that way for most conversions. It sneaks up on you."

The external kick kept on kicking. More precisely, the revelation *became* his work. As Girard noted: "Everything came to me at once in 1959. I felt that there was a sort of mass that I've penetrated into little by little. Everything was there at the beginning, all together. That's why I don't have any doubts. There's no 'Girardian system.' I'm teasing out a single, extremely dense insight."[6]

If his words are to be taken at face value—why shouldn't they be, really?—he had the glimmerings of all the future phases of his work, from imitative behavior, to the nature of desire, to scape-goating, to lynching, to war, and ultimately to the ends of the world, all in this intense period of several months. This should not be taken as a claim of divine imprimatur on his oeuvre. Nevertheless, for the one who experiences this kind of mental acceleration, the experience is persuasive, penetrating, and unforgettable.

I suspect that this experience explains his occasional impatience with objections, his eagerness to hurry along to the next phase of his work. He had, to some extent, a whole map of knowledge that needed to be drawn, defined, and interpreted. It also illumi-nates the extent to which he has been a visionary as much as a scholar, and perhaps sometimes a visionary at the expense of being a scholar. A close colleague, Jean-Pierre Dupuy, a leading thinker about technology, society, and nuclear deterrence from Paris' École Polytechnique and Stanford—and an important champion for Girard's oeuvre—nevertheless pointed out that Girard could be slapdash, he could be disinterested in the critical questions his work raised, and that current translations of his major works are problematic.

Girard appears to have had what has been called an "intellectual vision," which is usually unaccompanied by Technicolor imagery or thunder or any visual component at all. Such an experience can last more than a year. Its enduring souvenir is a sense of inner poise and direction. Oughourlian put it this way: "He explained meeting with Whoever"—in other words, his own meeting on the road to Damascus. "This is very important. It explains much of his psychology. He has a certainty and quietness and peacefulness that don't exist in normal people...When Moses met God, he was never the same," he explained to me. "If I had an experience of the kind, it would change my life. It's one thing to know about Napoleon, it's another to meet with Napoleon."

History abounds with precedents for such non-rational encounters, including some famous ones—Socrates and Pythagoras among them. I suspect Dante experienced something similar in what is perhaps the greatest conversion story in Western history. Another Hopkins's colleague, Charles Singleton, perhaps the foremost Dante scholar of the century, often remarked that the fiction of the *Commedia* is that it is not fiction—but that may be the secular scholar's own wishful thinking. The very first canto of the *Commedia* drops a clue: Dante uses the verb "*mi ritrovai*", rather than "*mi trovai*" in the first lines of the *Inferno*. That is, he doesn't say "I found myself" (as most translate it) but rather "I recovered myself." Singleton suggests that the term hints at an inwardness, an awareness, and the awakening of conscience.[7] That would appear to be an understatement. Dante is suddenly, alarmingly "awake" to his perilous spiritual condition, and about to undergo a mind-bending set of experiences in this altered state. His contemporaries seem to have thought so: Boccaccio relates that they saw Dante's singed beard as proof of his infernal journey.

IV

Because Girard rarely discussed his radical encounter, it might be useful to review a few other cases to contextualize what proved difficult to explain in words. It's possible, at least, to illustrate the range of conversion experiences, whether or not they resulted in an actual change of religion. Two more cases, then, this time from the seventeenth century: Pascal and Descartes both lived during Europe's first "total war," the bloody debacle known as the Thirty Year's War—one at the beginning, the other at the end of that conflict.

As a young soldier, Descartes had a series of visions on the night of November 10–11,1619, that would change his life. While billeted in Neuburg an der Donau, Germany, Descartes shut himself in a small heated room to escape the bitter cold of a lashing winter storm and freezing rain. After he dozed off, he had three troubling visions—just like Ebenezer Scrooge—and determined that they were a divine message. He would spend the rest of his life trying to decipher what they meant. What we call Cartesianism exists because this particular man believed in his dreams. In them, he saw all truths were linked with one another, so that finding one truth and proceeding with logic would crack open the world of science. He would go on to formulate analytical geometry and explore the idea of applying the mathematical method to philosophy. However secular the content of the dreams appeared, his first resolution afterward was to make a pilgrimage to Our Lady of Loreto. Were they just dreams? Not likely. For most of us, our dreams are insubstantial stuff, and not the basis of mathematics and science.

The genius mathematician credited with inventing the calculator, Blaise Pascal, experienced a "first conversion" after his exposure to Jansenism, and began to write on theological subjects soon afterwards, in 1647. After a "falling away" period, his second conversion

occurred on the night of November 23, 1654, after his horses plunged off the Pont de Neuilly and threw him into the roadway. Hours later, between 10:30 p.m. and 12.30 a.m., light had flooded his room and, whatever he experienced in the minutes that followed, he afterward wrote a brief note to himself which began, "Fire. God of Abraham, God of Isaac, God of Jacob, not of the philosophers and the scholars. Certitude. Certitude. Feeling. Joy. Peace . . . Joy, joy, joy, tears of joy . . ." and concluded by quoting Psalm 119:16: "I will not forget thy word. Amen." He had this document carefully sewn into his coat, transferring it when he changed clothes, as a constant reminder. His major religious works followed, including *Lettres provinciales,* which Voltaire praised as the best book that had yet appeared in French, and the *Pensées,* unfinished at his death.

Long ago, certainly. But a more recent experience by a former communist might also be illuminating. In spring 1938, the influential philosopher Simone Weil spent ten days at the Benedictine Abbey of Solesmes, and had an entirely unanticipated encounter that was to have a lasting effect in her life. "I had vaguely heard tell of things of this kind, but I had never believed in them," she said. She had never read any mystical works, so the contact was "absolutely unexpected."[8] The experience began a journey that would culminate in her spiritual masterpieces, including *Waiting for God, Gravity and Grace,* and *The Need for Roots.* It would end with a request for a deathbed baptism, a request that remains generally unknown, and was only revealed decades later by her close friend Simone Deitz, who performed the rites a few months before Weil's death.[9]

Girard recorded his experience not in science, poetry, or mathematics, but in erudite French prose; he challenged, he reasoned, but he also made spectacular intuitive leaps of invention. ("René is brilliant enough to find reasons," as Macksey once said.) In an era where the humanities are no longer our culture's lingua franca, he transmitted his new understanding largely through the social sciences. He pored over ancient texts and studied anthropology, sociology,

history, trying to explain what he had understood quickly, over a very condensed period in those months of 1958 and 1959. But the social sciences provided an inadequate vehicle—like trying to describe the Eiffel Tower along a single line—and he would turn to another language to explain what he had understood: "Christianity reveals its power by interpreting the world in all its ambiguity. It gives us an understanding of human cultures that is incomparably better than that offered by the social sciences. But it's neither a utopian recipe nor a skeleton key for deciphering current events."[10]

In later years, he would warn against a religion designed to increase the comfort of our lives in a consumer society, prettified by "Christian values," which he said would be akin to having a tiger by the tail. "If I'm right, we're only extricating ourselves from a certain kind of religion so as to enter another, one that's infinitely more demanding because it's deprived of sacrificial crutches. Our celebrated humanism will turn out to have been nothing but a brief intermission between two forms of religion."[11]

But the story all began in those tumultuous months before the spring of 1959. It would lead him to promulgate not a tame-dog Christianity, but one for the twentieth and twenty-first centuries, a Christianity that could reveal and respond to civilizations born in repeated, imitative violence, in a world driven forward by envy, competition, and strife.

Let us return to *Deceit, Desire, and the Novel*, and Girard's description of the effect his personal revolution had on that first pivotal book:[12] "I started working on that book very much in the pure demystification mode: cynical, destructive, very much in the spirit

of the atheistic intellectuals of that time." He continued: "I was engaged in debunking, and of course recognizing mimesis is a great debunking tool because it deprives us moderns of the one thing we think we still have left, our individual desire. This debunking is the ultimate deprivation, the dispossession, of modern man. The debunking that actually occurs in this first book is probably one of the reasons why my concept of mimesis is still viewed as destructive. Yet I like to think that if you take this notion as far as you possibly can, you go through the ceiling, as it were, and discover what amounts to original sin."

A radical debunking can bring one to the precipice of a conversion experience, or something akin to it. He argued that the great writers he was studying had departed significantly from the original plan for their books, and the final product was startlingly different. He explained:

> The author's first draft is an attempt at self-justification, which can assume two main forms. It may focus on a wicked hero, who is really the writer's scapegoat, his mimetic rival, whose wickedness will be demonstrated by the end of the novel. It may also focus on a 'good' hero, a knight in shining armor, with whom the writer identifies, and this hero will be vindicated by the end of the novel. If the writer has a potential for greatness, after writing his first draft, as he rereads it, he sees the trashiness of it all. His project fails. The self-justification the novelist had intended in his distinction between good and evil will not stand self-examination. The novelist comes to realize that he has been the puppet of his own devil. He and his enemy are truly indistinguishable. The novelist of genius thus becomes able to describe the wickedness of the other from within himself, whereas before it was some sort of put-up job, completely artificial. This experience is shattering to the vanity and pride of the writer.

According to Girard, the author's existential downfall makes a great work of art possible, putting into motion a sort of psycho-

spiritual dominoes: The crisis of the characters in the books triggered an existential downfall for the novelists, which now made a different future possible for the man reading them centuries later.

What was true for Cervantes was true for Girard, at one remove. "Once the writer experiences this collapse and a new perspective, he can go back to the beginning and rewrite the work from the point of view of this downfall. The novel is no longer self-justification. It is not necessarily self-indictment, but the characters he creates are no longer 'Manichaean' good guys or bad guys."

Girard continued: "So the career of the great novelist is dependent upon a conversion, and even if it is not made completely explicit, there are symbolic allusions to it at the end of the novel. These allusions are at least implicitly religious. When I realized this, I had reached a decisive point in the writing of my first book, above all in my engagement with Dostoevsky." Dostoevsky's Christian symbolism was important for him, particularly Stepan Verkhovensky's deathbed conversion in *Demons,* but also the end of *Crime and Punishment* and *The Brothers Karamazov.* "The old Verkhovensky discovers that he was a fool all the time and turns to the Gospel of Christ. This is the conversion that is demanded by a great work of art."

VI

Girard referred to his enlightening winter of 1958–59 as an "intellectual-literary conversion," but it was only the first trip to Damascus. He would have a second journey, more intense than the first, which he would describe in retrospect as an easy bliss.

The two-hour train rides to and from Pennsylvania had initially provided a meditative respite. "I remember quasi-mystical

experiences on the train as I read, contemplated the scenery, and so on," he said. The sights were little more than scrap iron and the vacant lots in an old industrial region, "but my mental state trans-figured everything, and, on the way back, the slightest ray from the setting sun produced veritable ecstasies in me."[13]

The Pennsylvania Railroad would be the setting for a deeper experience—a second road to Damascus. Initially, it had offered a pleasant and undemanding experience, until he discovered some time later, one morning on the familiar train ride to Bryn Mawr, an ominous spot on his forehead. The doctor failed to tell him this type of cancer was eminently curable. "So to me it was as though I was under a death sentence. For all I knew, I had melanoma, the worst form of skin cancer."

"So my intellectual conversion, which was a very comfortable experience, self-indulgent even, was totally changed. I could not but view the cancer and the period of intense anxiety as a warning and a kind of expiation, and now this conversion was transformed into something really serious in which the aesthetic gave way to the religious."

It was Lent. He was thirty-five years old. He had never been a practicing Catholic. "I will never forget that day. It was Holy Wednesday, the Wednesday before Easter," which would have been March 25, 1959. "Everything was fine, completely benign, no return of the cancer."

In Baltimore, Girard met with the befuddled Irish priest who had a hard time understanding what he had undergone. The Girard children were baptized, with Freccero acting as godfather, and René and his wife Martha renewed their vows, at the suggestion of the priest. (Martha is quite firm that they weren't "remarried," as even René sometimes said.)

"I felt that God liberated me just in time for me to have a real Easter experience, a death and resurrection experience," Girard told James Williams in an interview decades later. The consent of

the will occurred in what he called the "first conversion" experience. The second conversion gave him urgency, depth, and the endurance to take the next steps of his journey.

He never seemed to doubt that he was right, or rather that whatever happened to him that winter of 1958–59 was right, and it was that understanding that drove his writing. "My intuition comes first, and it leads me toward vivid examples, or burns them into my memory when I happen upon them by chance," he explained. This has led to misunderstanding, even condemnation, among "specialists." Girard admitted, "I'm probably partly responsible for this situation. I'm under the impression that I've never been able to lay out my insight in the most logical, most didactic, and most comprehensible order."[14]

His conversion would be a costly personal decision. It closed off an audience; it alienated potential readers and fans. Without regard to the professional price he would have to pay, he was open with his friends and colleagues—and also in his writing. He never backed away from what he understood, in startling moments of clarity, to be the truth.

VII

The seismic shift of that winter of 1958–59 left some unexpected aftershocks. "Curiously, my conversion had made me sensitive to music, and I was listening to a lot of that," he recalled. "What little musical knowledge I have, about opera in particular, dates from that period. Oddly enough, *The Marriage of Figaro* is, for me, the most mystical of all music. That, and Gregorian chant."[15]

Mozart's comic opera is permeated with themes enduring love in the face of adversity, love rendered almost supernatural by the

music. It also has perhaps the most exquisite portrayal of forgiveness in the entire opera canon, when the Countess' merciful *Più docile io sono* opens out to a sublime ensemble. No surprise, then, that forgiveness was to become a theme in Girard's writings for the rest of his life. As for the Gregorian chant, Macksey was not surprised by Girard's fondness for the Latin Mass; after all, he told me, Girard was practically born in a museum.

"I am an ordinary Christian," Girard told Williams, anticipating those who would make something grand of his faith and his conversion. Sometimes people did make something grand of it. Some years ago, at the end of an online interview with Girard, someone in the comments section asked if Girard was Catholic. One reader wrote a little pompously, "René does worship as a Catholic. Precisely because he is Catholic. I would add that he also worships majestically in a beautiful small Catholic Church near Stanford University attending Sunday Mass celebrated by priests who have not forgotten that the Mass is a true sacrifice."

Girard would have chuckled at such a glorious description. He attended the century-old landmark St. Thomas Aquinas church in the back third of the pews, on the left side from the entrance, quietly, and without any commotion or self-importance that might draw attention to himself. It was a Gregorian Mass.

NOTES

1. Published first as *Mensonge romantique et vérité romanesque* in 1961 by Grasset; and in English as *Deceit, Desire, and the Novel: Self and Other in Literary Structure* by Johns Hopkins University Press in 1966.

2. René Girard, with Pierpaolo Antonello and João Cezar de Castro Rocha, *Evolution and Conversion: Dialogues on the Origins of Culture* (London: Continuum, 2007), 45.

3. Michel Treguer, *When These Things Begin*, trans. Trevor Cribben Merrill (Lansing: Michigan State University Press, 2014), 129.

4. Girard, *Evolution and Conversion,* 44.

5. Girard, *Evolution and Conversion,* 44.

6. Girard, *When These Things Begin,* 128–29.

7. Dante Alighieri, *The Divine Comedy: Inferno,* translated and with commentary by Charles S. Singleton (Princeton, N.J.: Bollingen Series, Princeton University Press, 1970).

8. Simone Weil, *Waiting for God* (New York: Routledge, 2010), 15.

9. Cf. *Spirit, Nature and Community: Issues in the Thought of Simone Weil*, by Diogenes Allen and Eric Springsted (Albany: State University of New York Press, 1994). Deitz explained that her long silence was at the request of Weil's mother, who said, "I don't want anyone to speak of that while I'm living." Hence, Deitz did not repeat the story during the lifetime of Madame Weil, who died in 1965.

10. Girard, *When These Things Begin,* 120.

11. Girard, *When These Things Begin,* 120–21.

12. Unless otherwise noted, his description of his two conversions occurs in his interview with James G. Williams, "Anthropology of the Cross," in *The Girard Reader,* James G. Williams, ed. (New York: Crossroad Publishing, 1996), 283–286.

13. Girard, *When These Things Begin,* 130.

14. Girard, *When These Things Begin,* 127.

15. Girard, *When These Things Begin,* 130.

CYNTHIA L. HAVEN'S work has appeared in *The Times Literary Supplement, The Nation, The Washington Post, Le Monde, La Repubblica, Die Welt, Zeszyty Literackie, Colta, Zvezda, The Los Angeles Times*, and elsewhere. Her *Evolution of Desire: A Life of René Girard* (2018), the first-ever biography of the French theorist, was praised in *The New York Review of Books, The Times Literary Supplement, The Wall Street Journal*, and many other publications. It was written while she was a visiting scholar at Stanford University.

She is the editor of René Girard's *All Desire is a Desire for Being: Essential Writings*, published in 2023 by Penguin Classics.

9 781963 319828